NIGHT IN THE GERMAN VILLAGE

Photographs By
ADI MIZRAHI

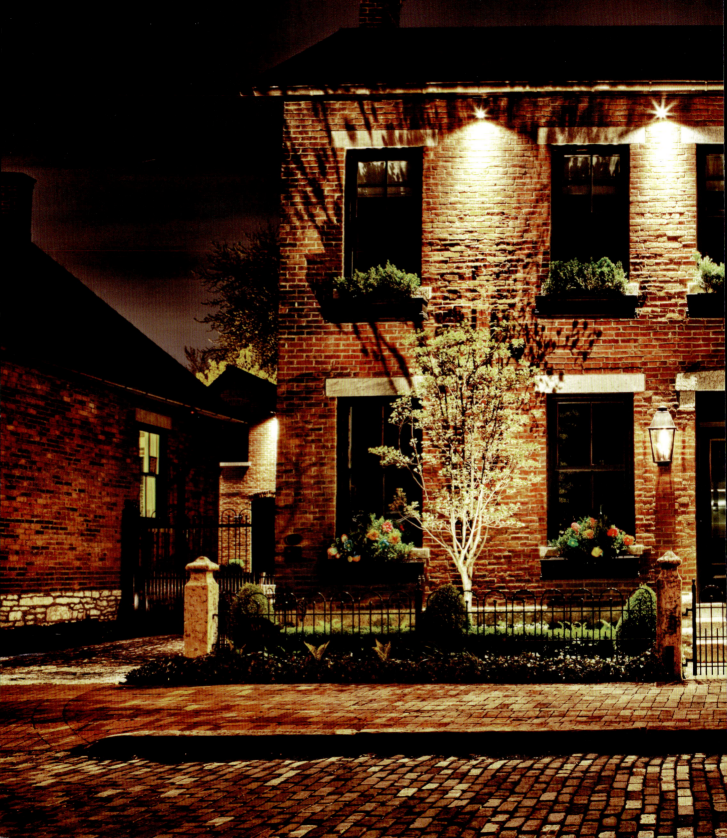

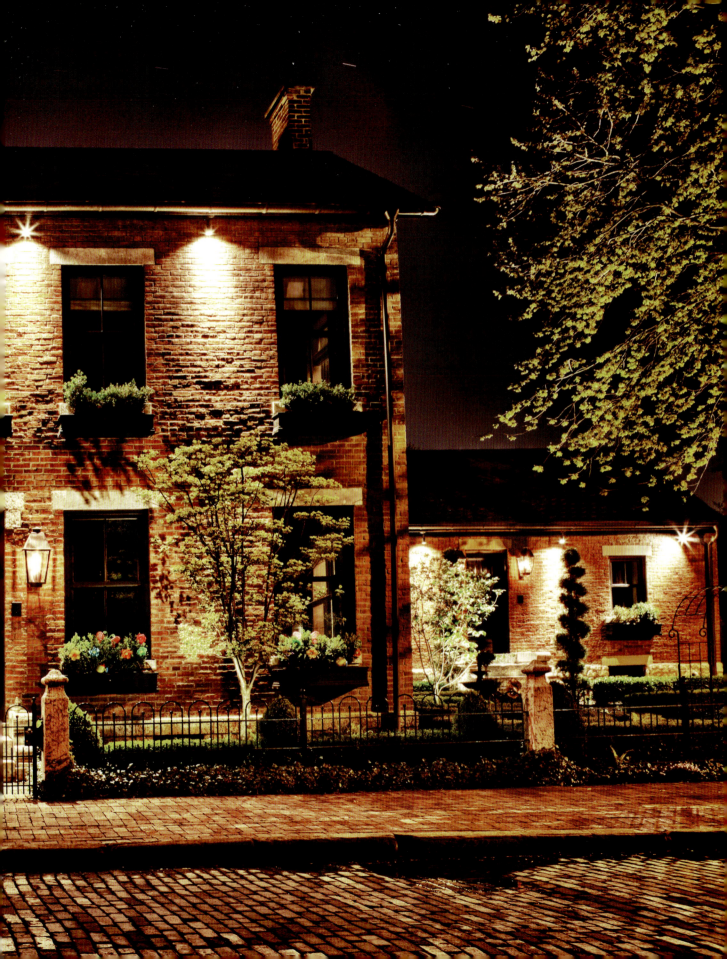

EACH YEAR, GERMAN VILLAGE receives thousands of visitors who feel transported through time in this pocket of Columbus, Ohio. Wandering along our brick streets and sidewalks, finding businesses alongside homes and enjoying our spectacular parks, guests cannot help but wonder how the neighborhood came to be and how it has remained so exceptional. And if our visitors feel lucky to have found German Village, our residents feel gratitude with each passing day, and every captured glimpse of the downtown skyline and spire of St. Mary's Church that let Villagers feel so nestled in an urban and historic sanctuary.

Originally known as the South End, today's German Village was originally plotted in the 1840s and saw tremendous growth as the country turned the corner into the 20th century. Industrious, politically savvy and increasing in number, Columbus' German population contributed to the city in innumerable ways, though their legacy is seen most visibly today in the architecture of German Village. From the simple story-and-a-half cottages to the whimsical Queen Annes and genteel Italianates, the architecture of German Village is at the same time both unique and everyday. The residential and commercial structures are representative of the times, the builders, and the Midwest interpretation of established architectural styles. What is clear is the fact that there is no place quite like German Village for its magic, its vibrancy, and its presence.

And just when residents and visitors alike thought they had seen all that German Village has to offer, Adi Mizrahi manages to add to its already complex aesthetic. Thanks to Mizrahi's abilities with High Dynamic Range Imaging (HDR) this dramatic collection makes Columbus' oldest historic district look nothing if not ethereal. There is clearly no season or time of day that does not suit the orange brick and gray slate that constitute so much of this neighborhood. These nighttime images offer a glimpse of German Village that is frequently seen but rarely captured and the collection as a whole strengthens the creative legacy that has become so much of today's German Village.

German Village is an historic district that lives and breathes in the 21st century. Residents honor the past by maintaining their historic structures in the present. German Village is not a museum and is anything but stagnant. The vibrancy and vitality of this neighborhood is immediately evident and hopelessly contagious. The sense of place is palpable, the sense of beauty inspires, and the sense of community is second to none and of that, the neighborhoods' earliest residents would be proud.

Jody Graichen

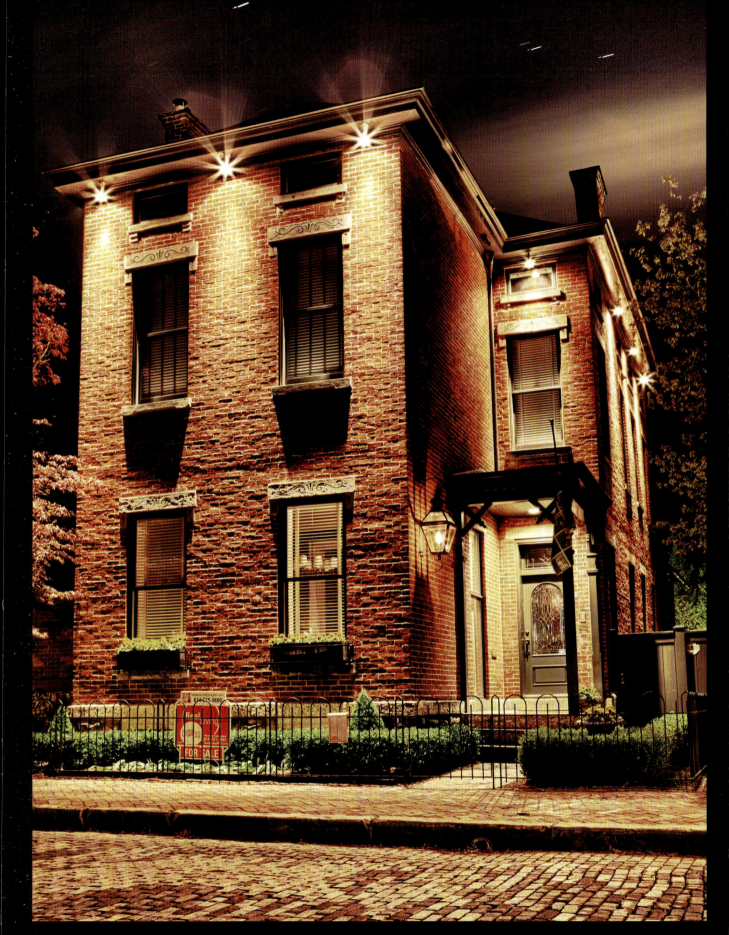

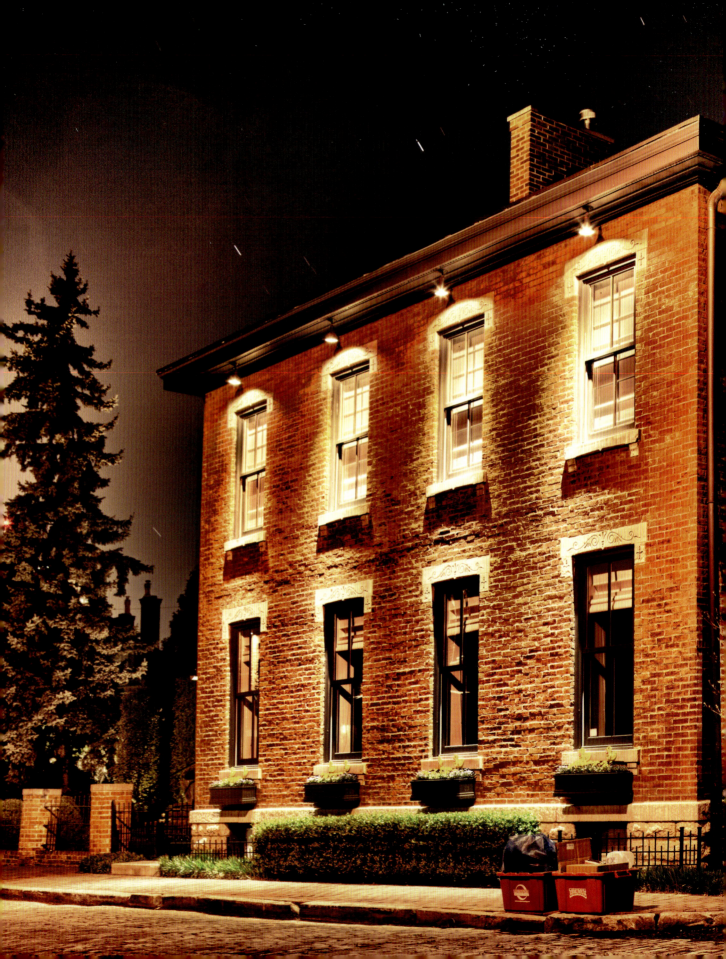

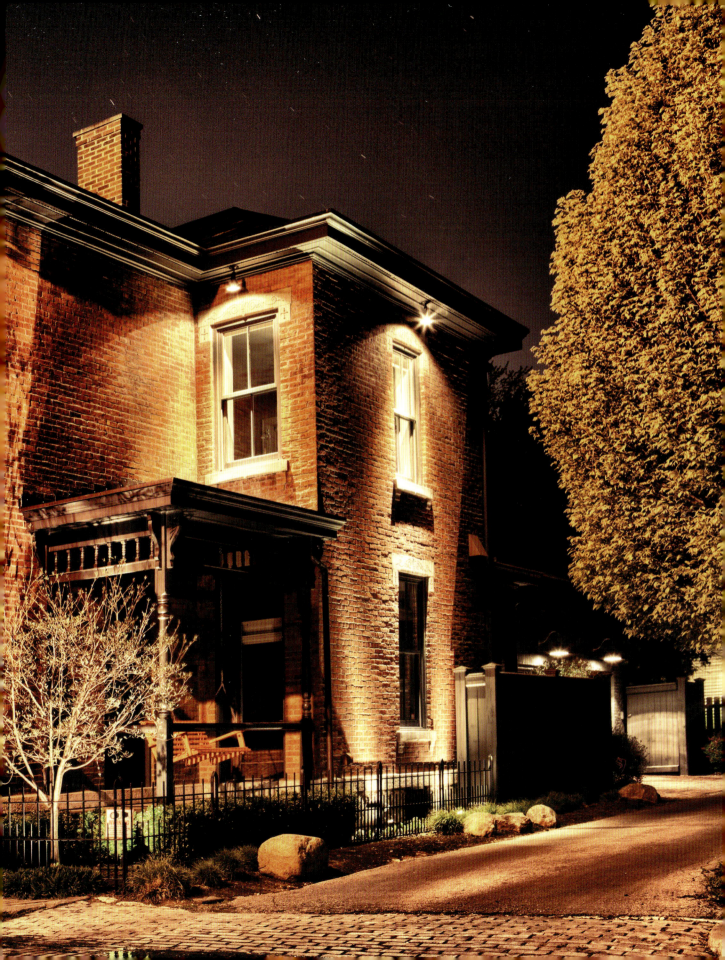

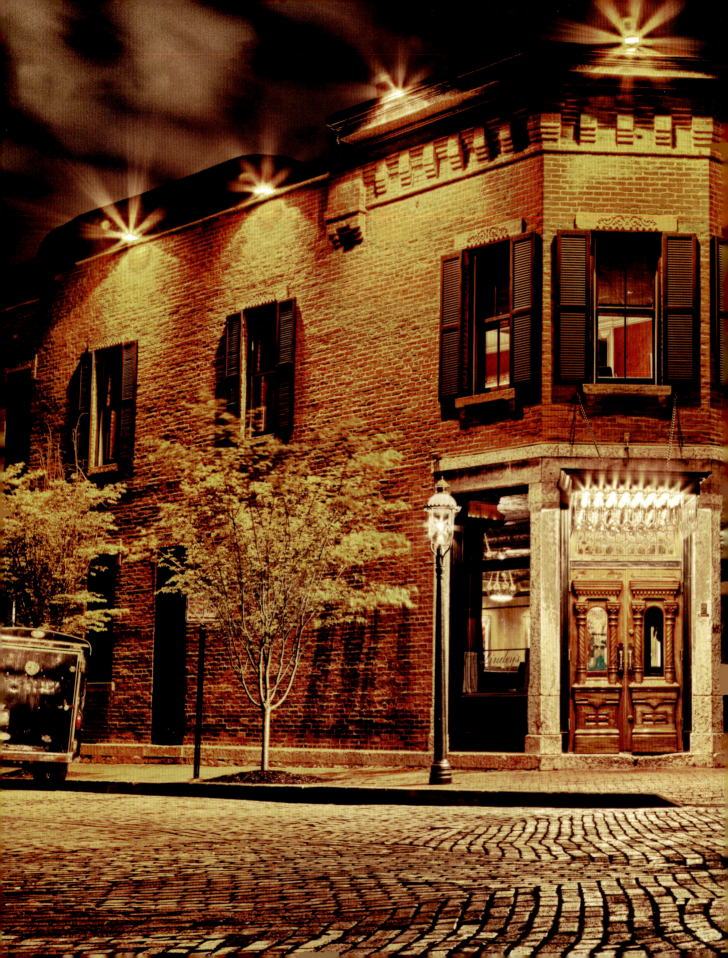

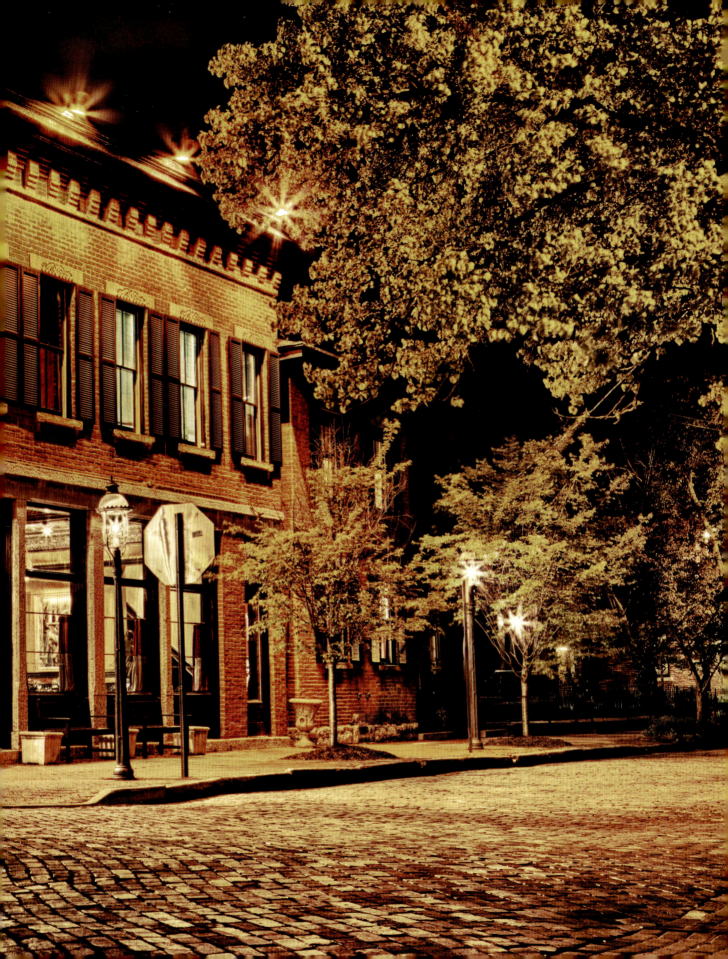

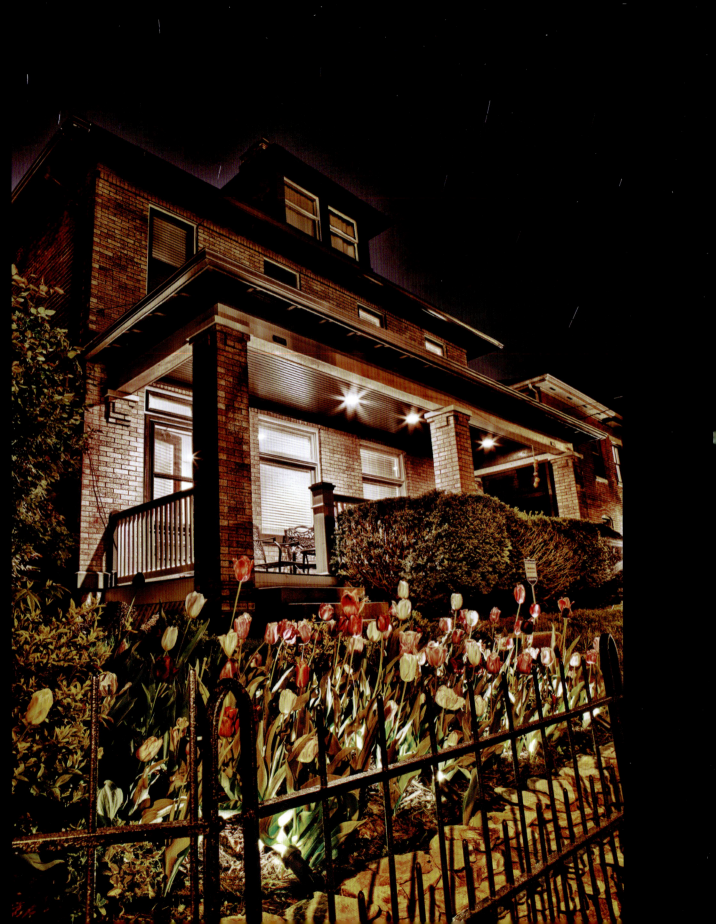

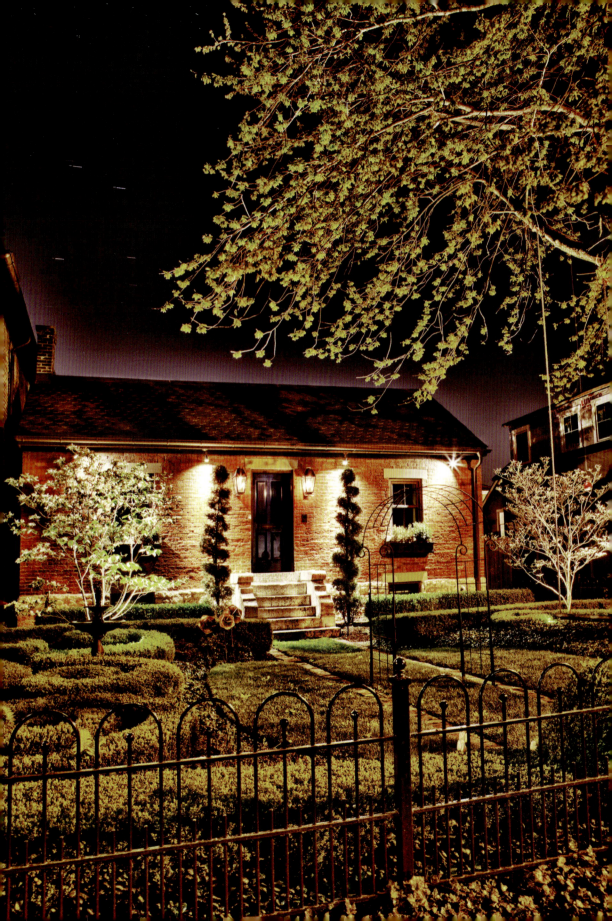

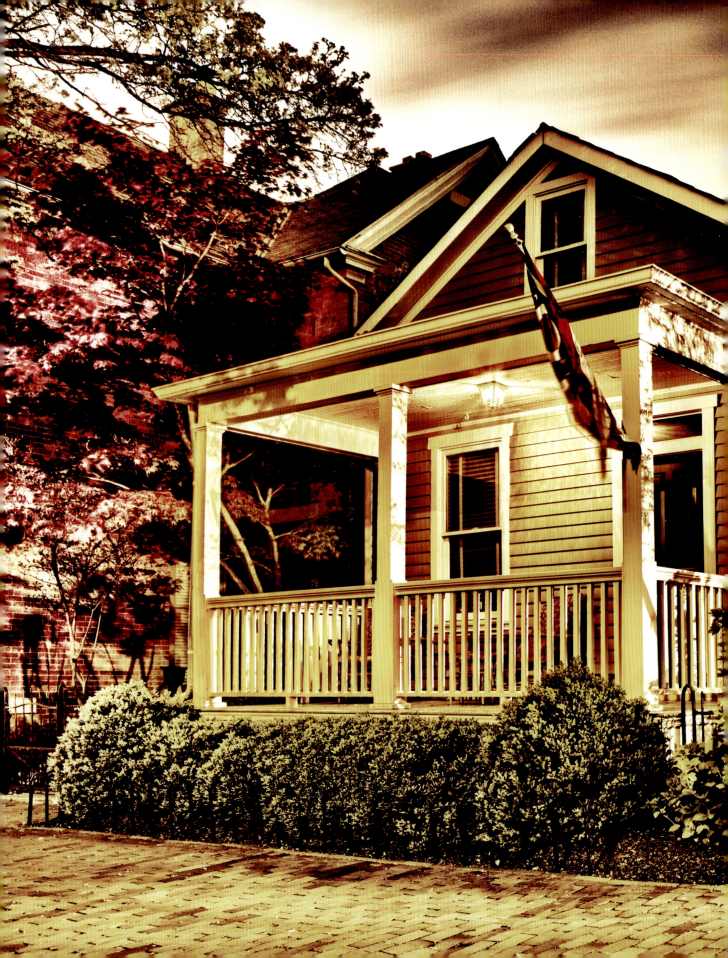

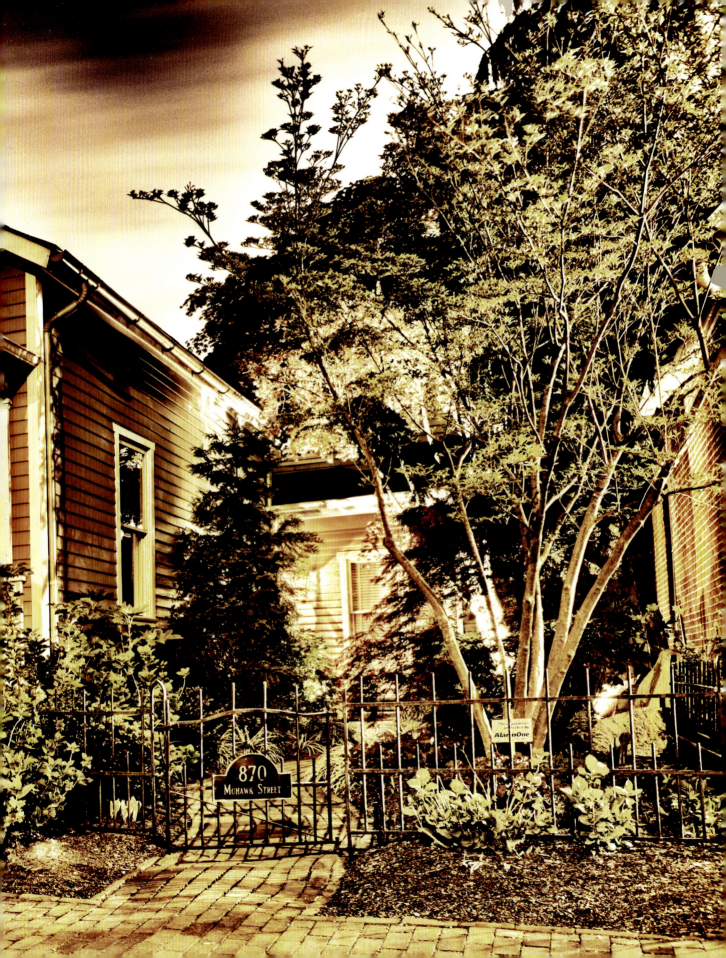

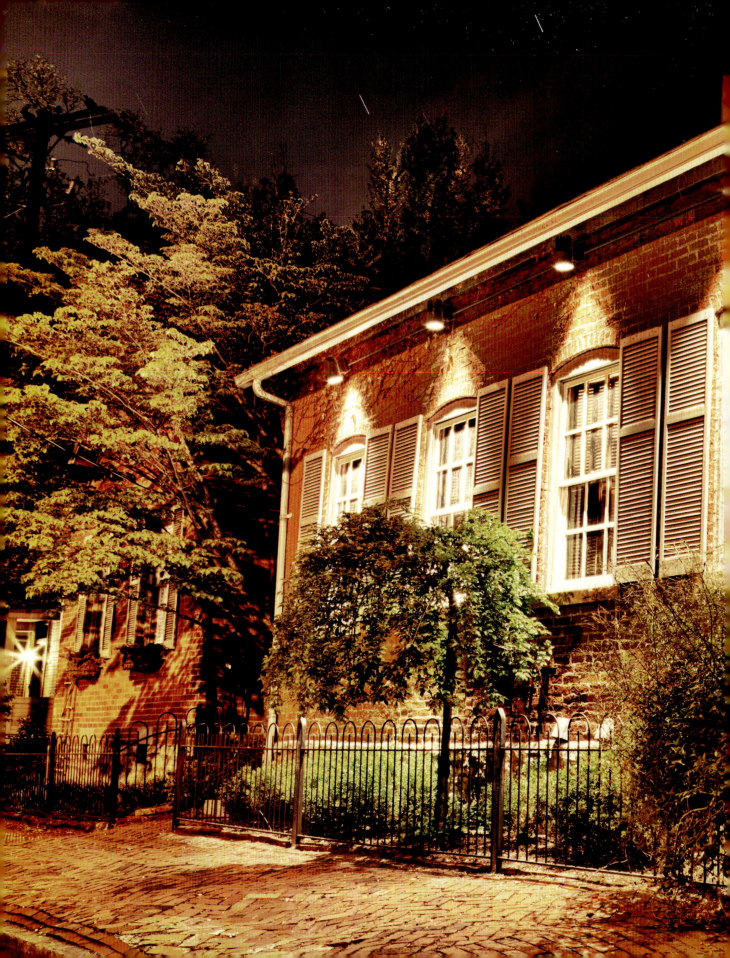

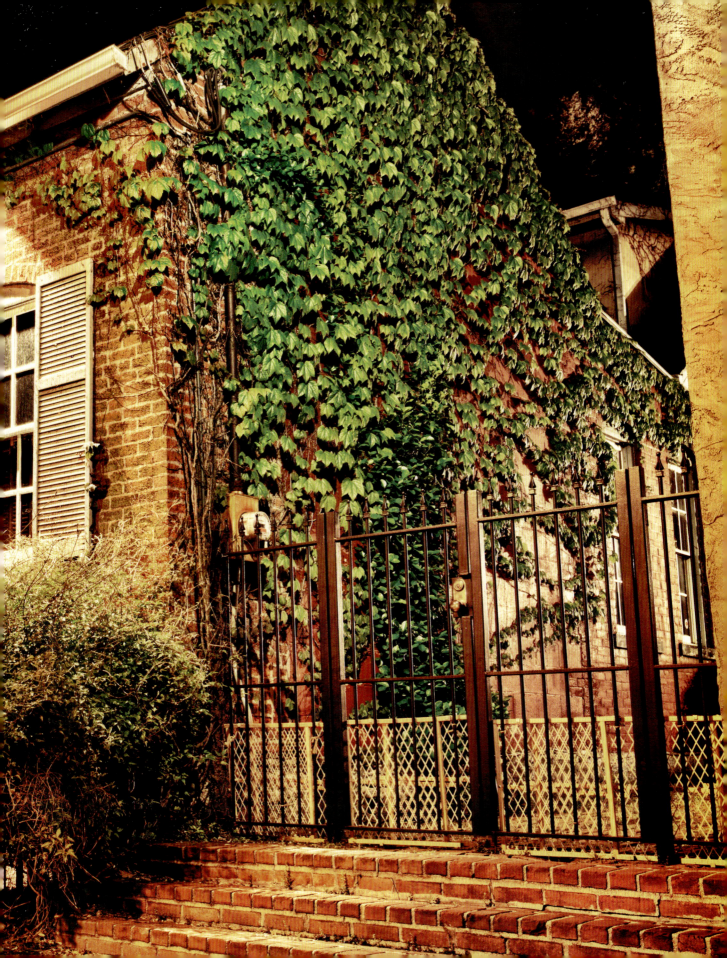

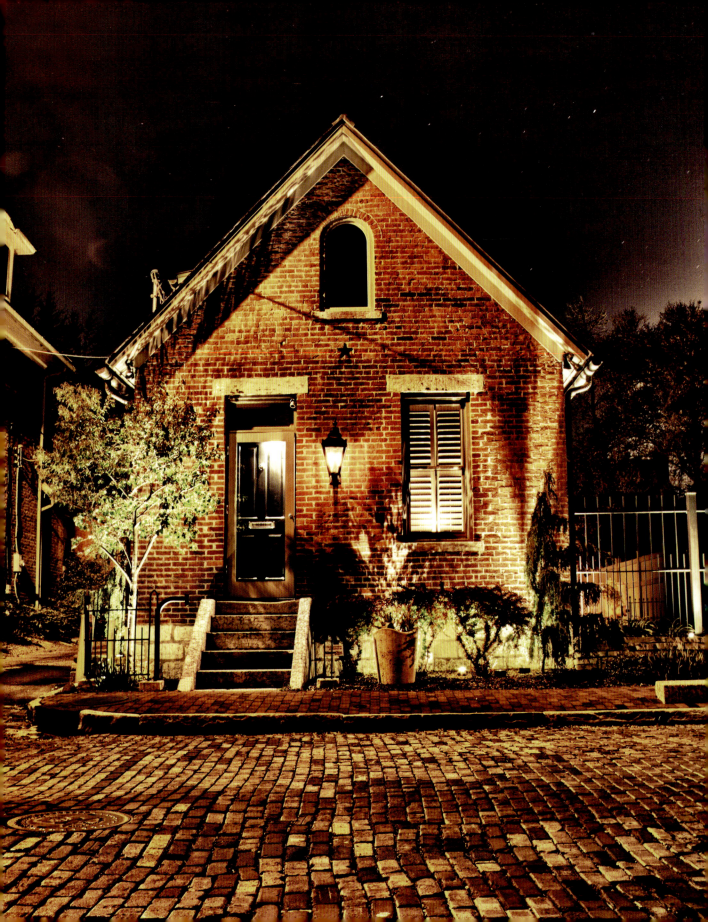

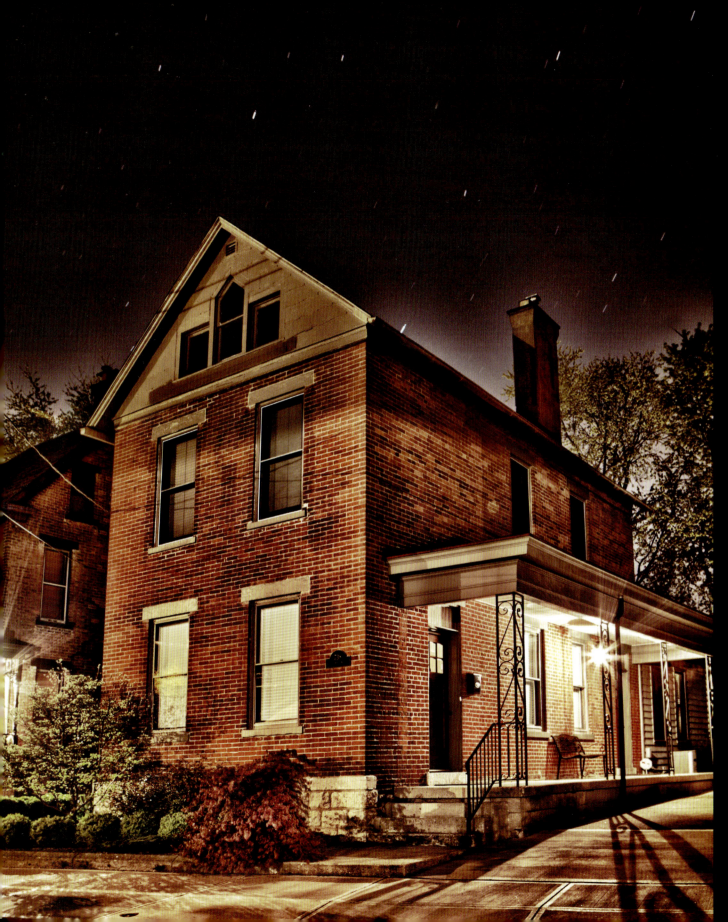

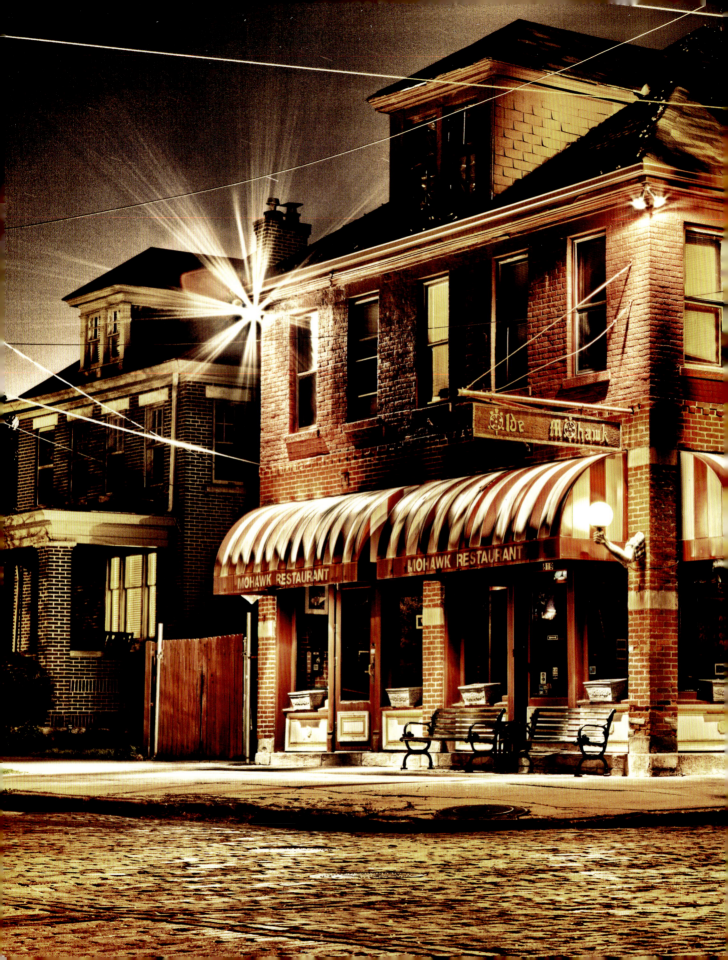

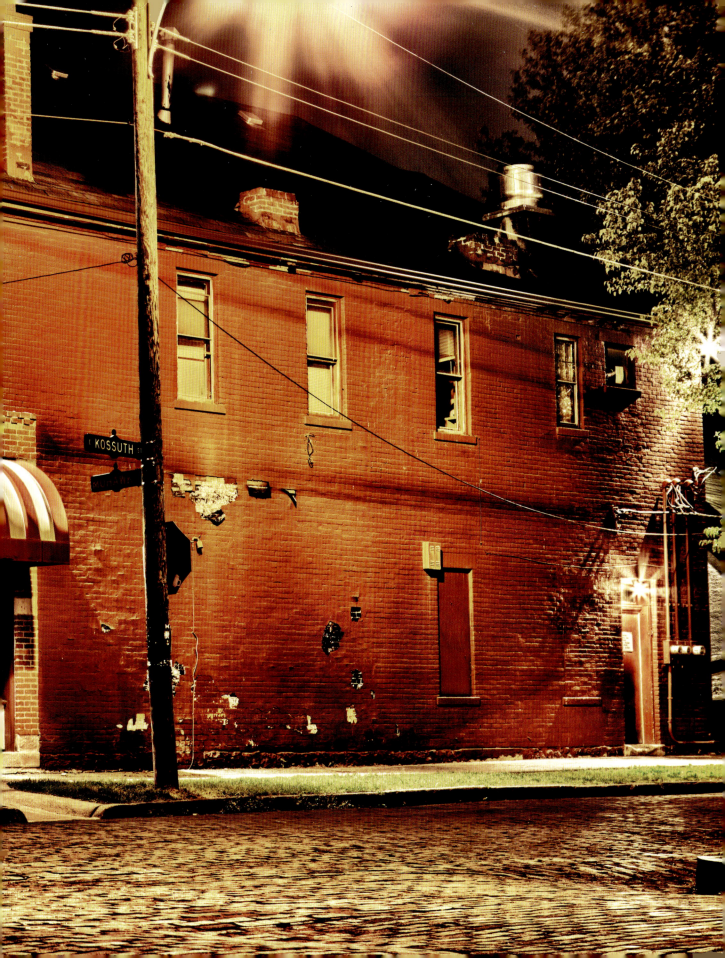

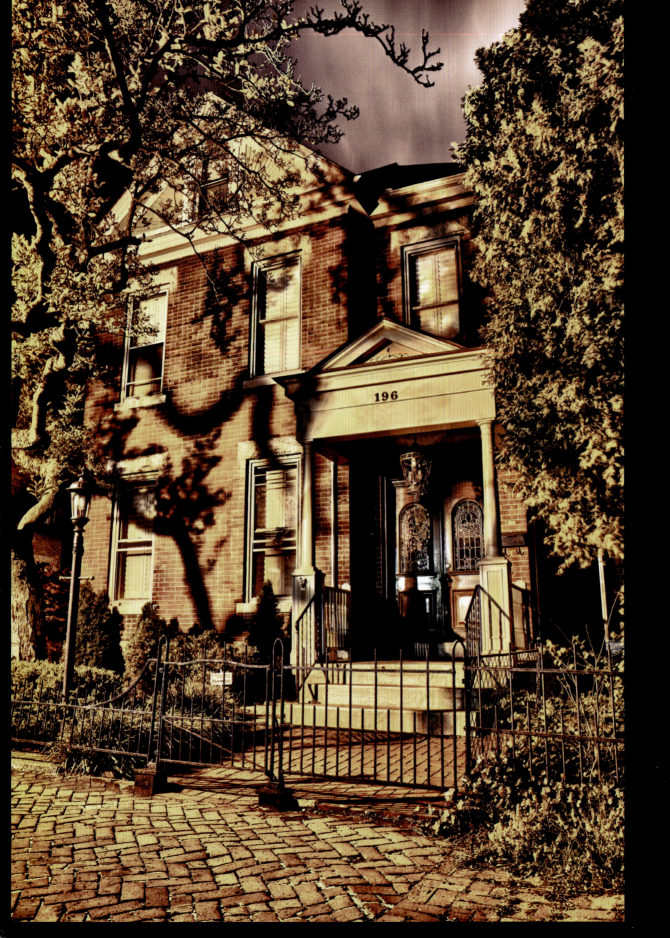

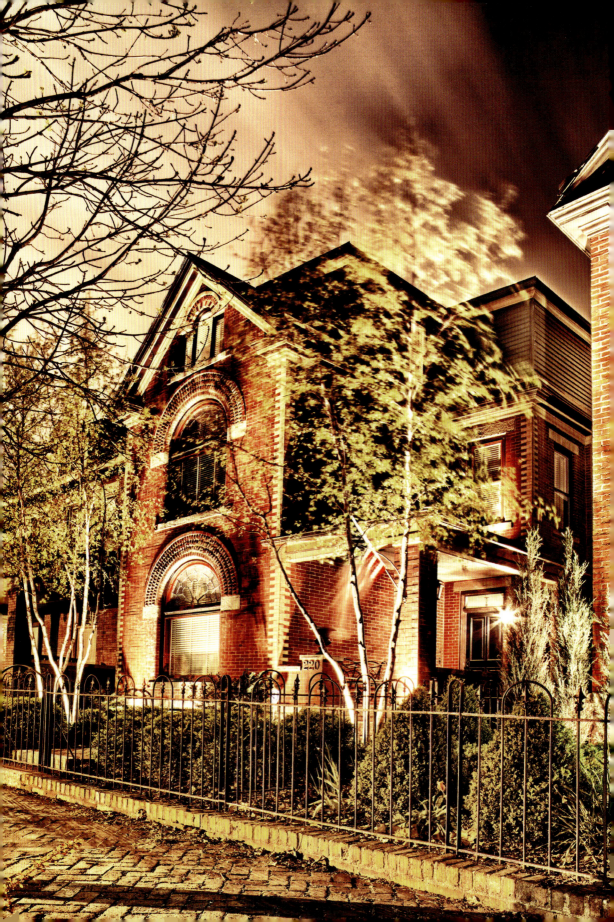

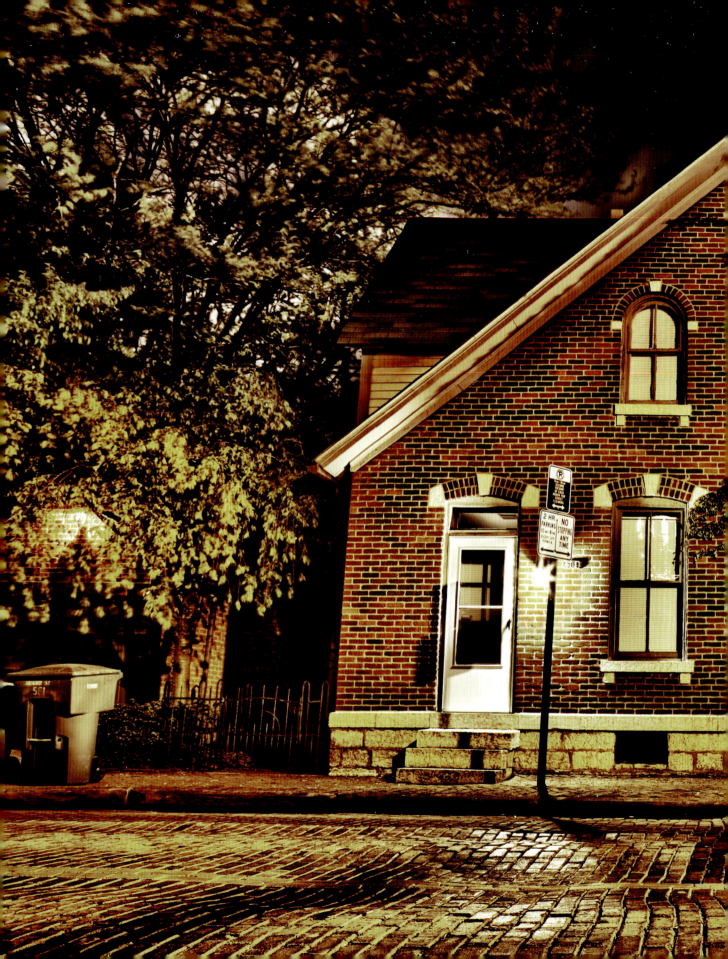

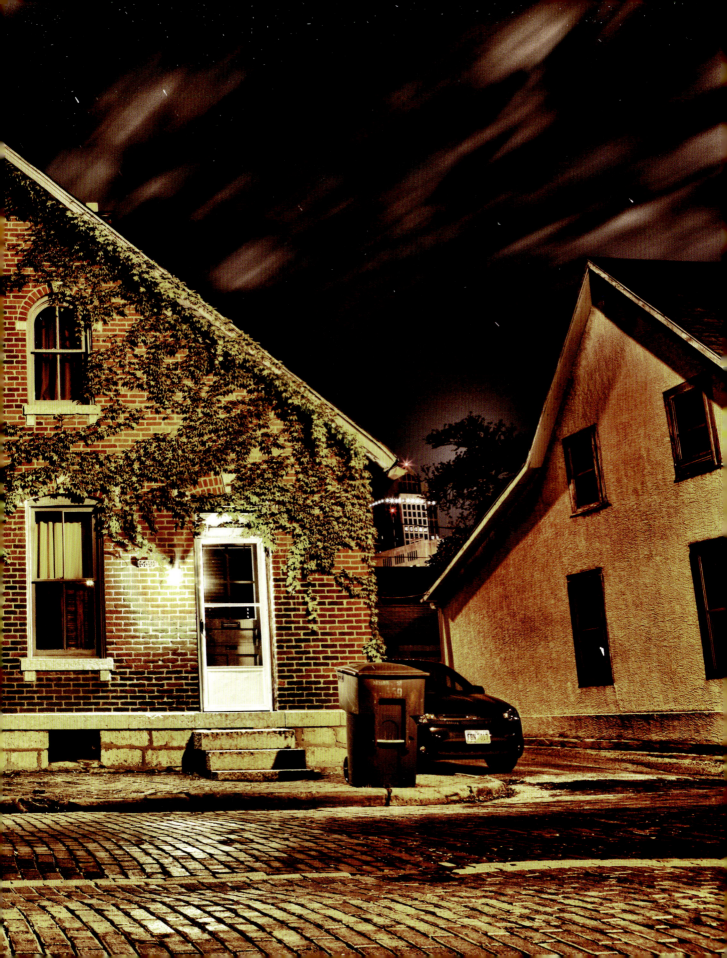

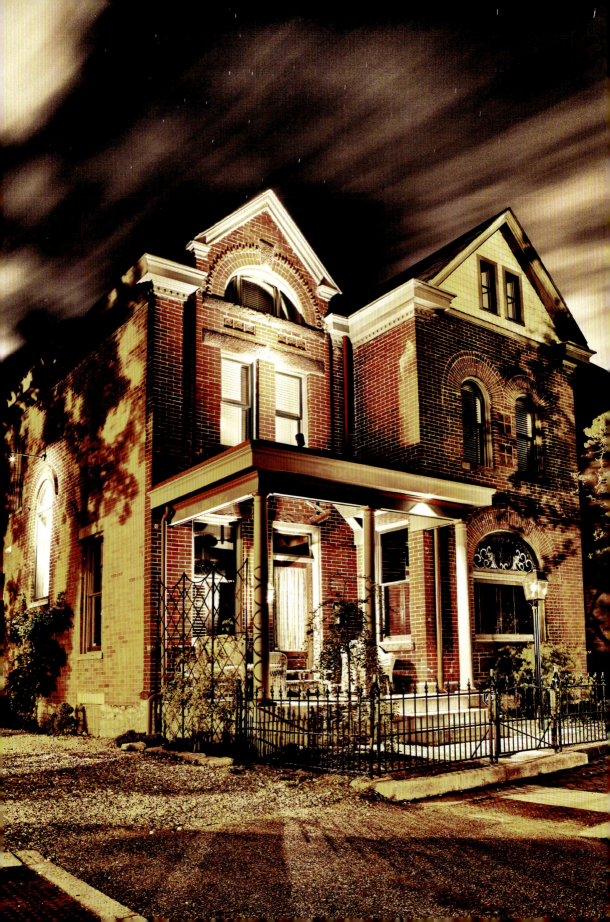

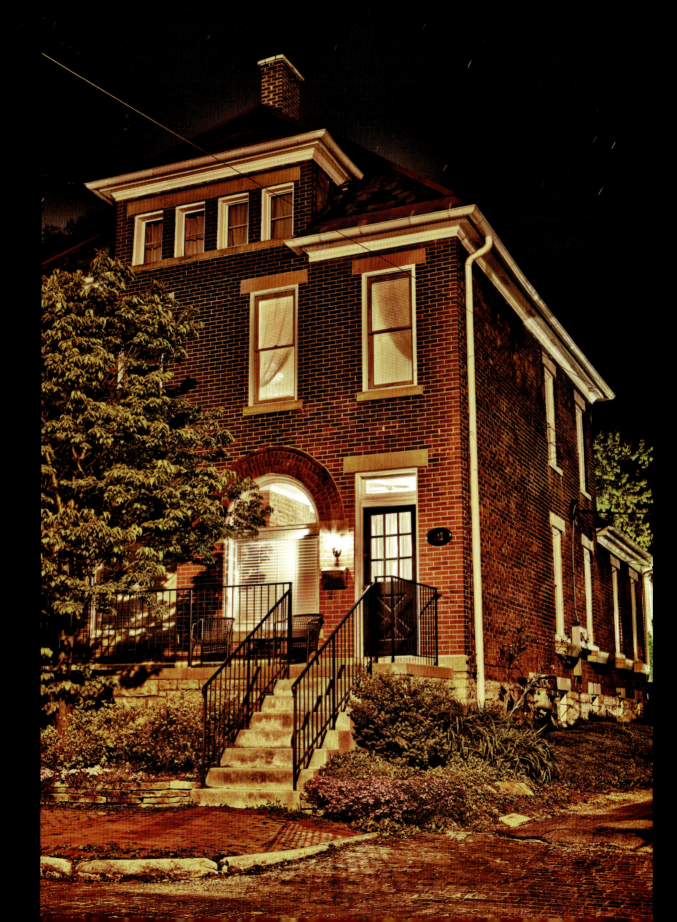

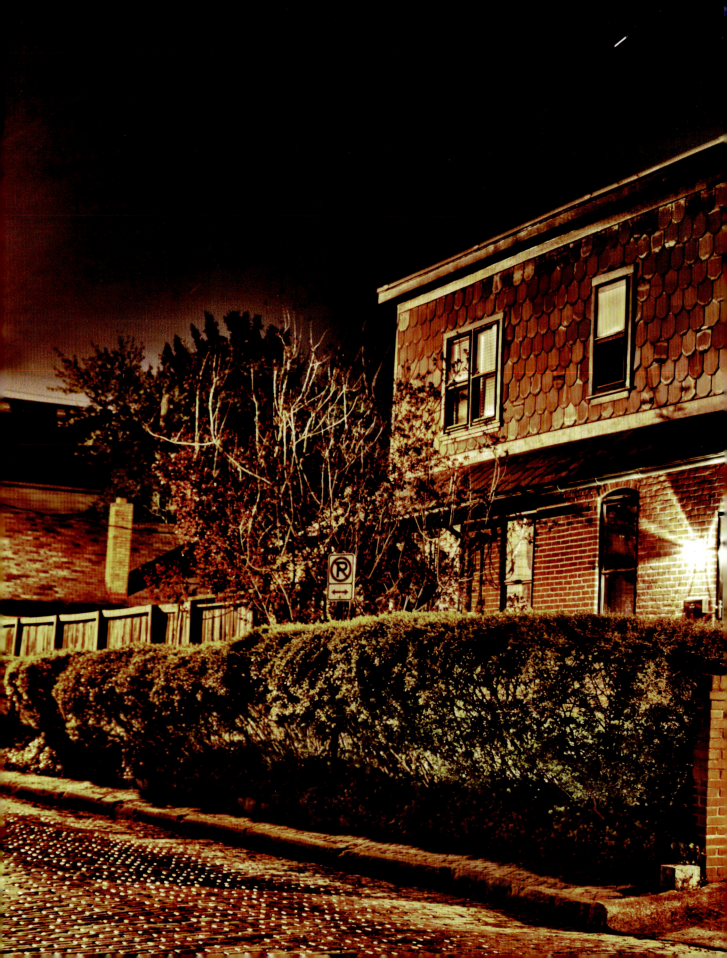

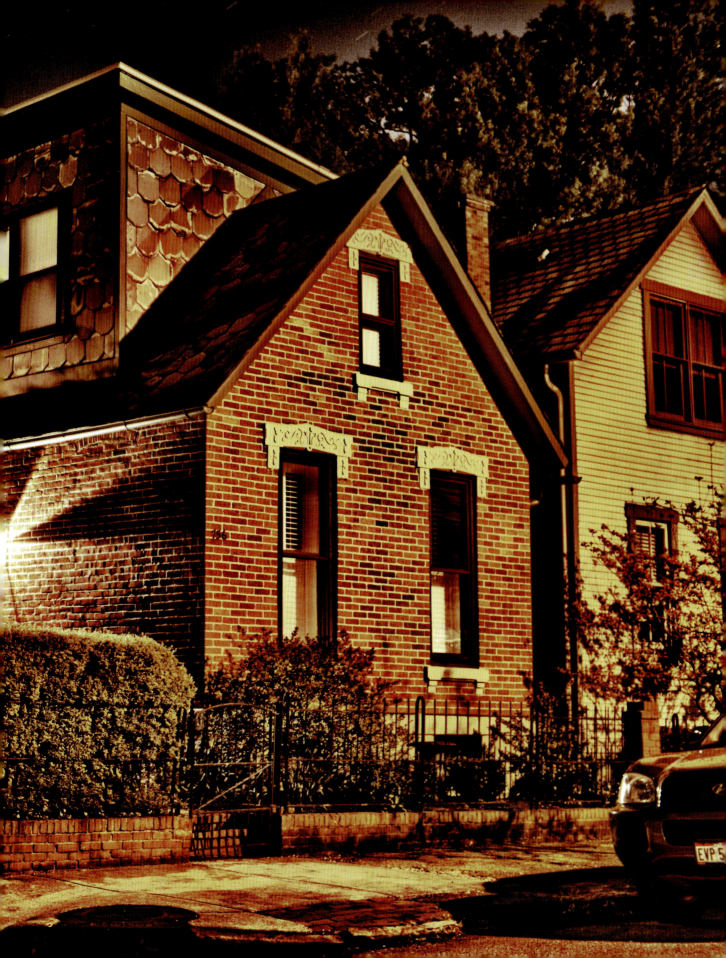

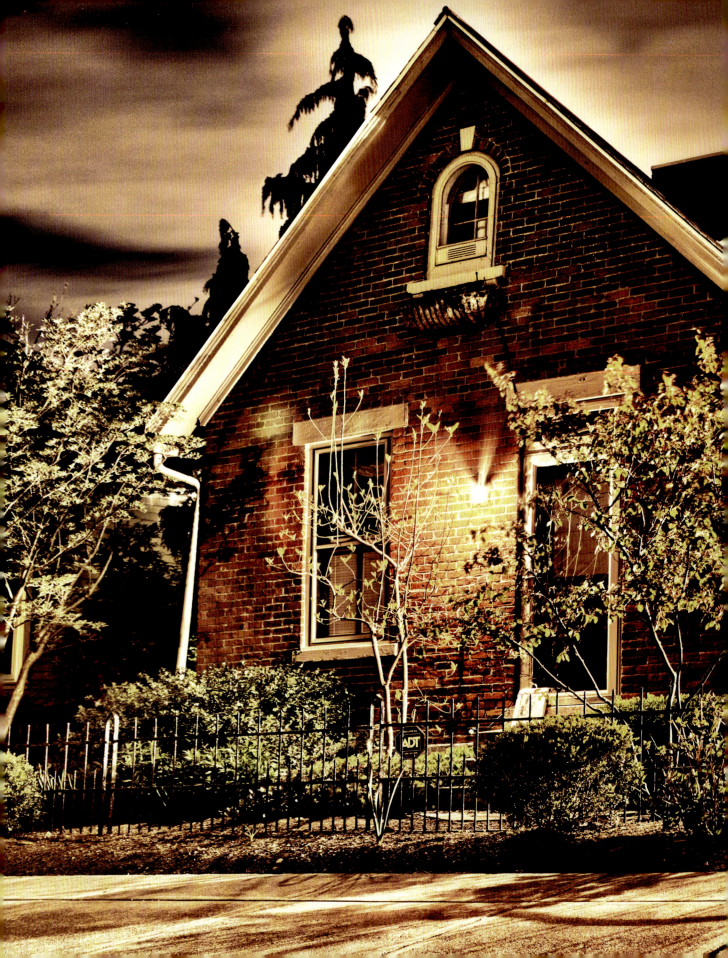

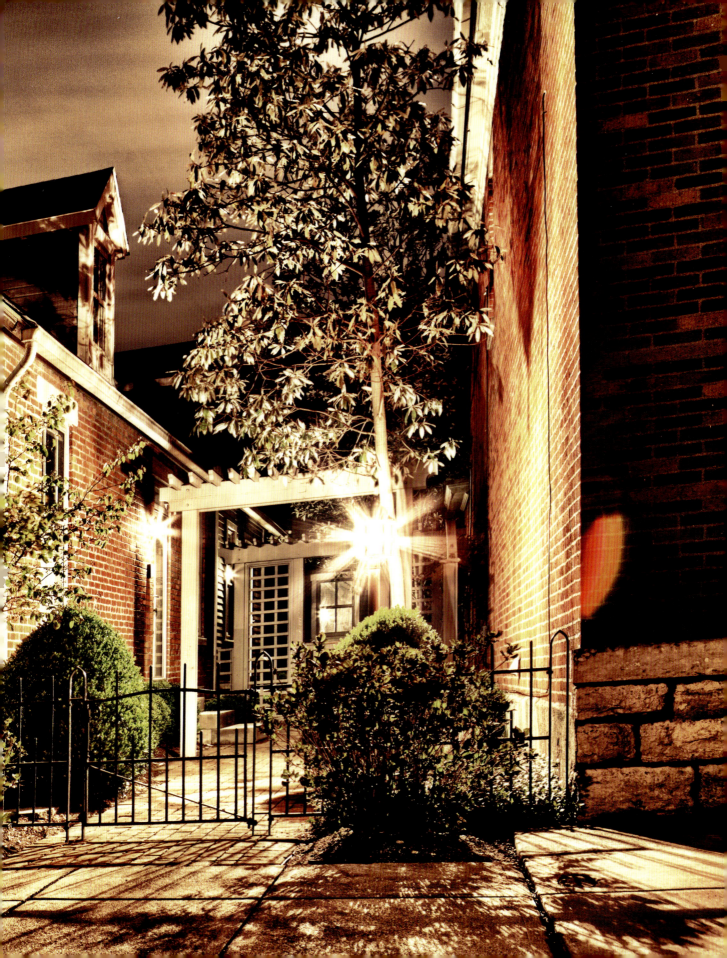

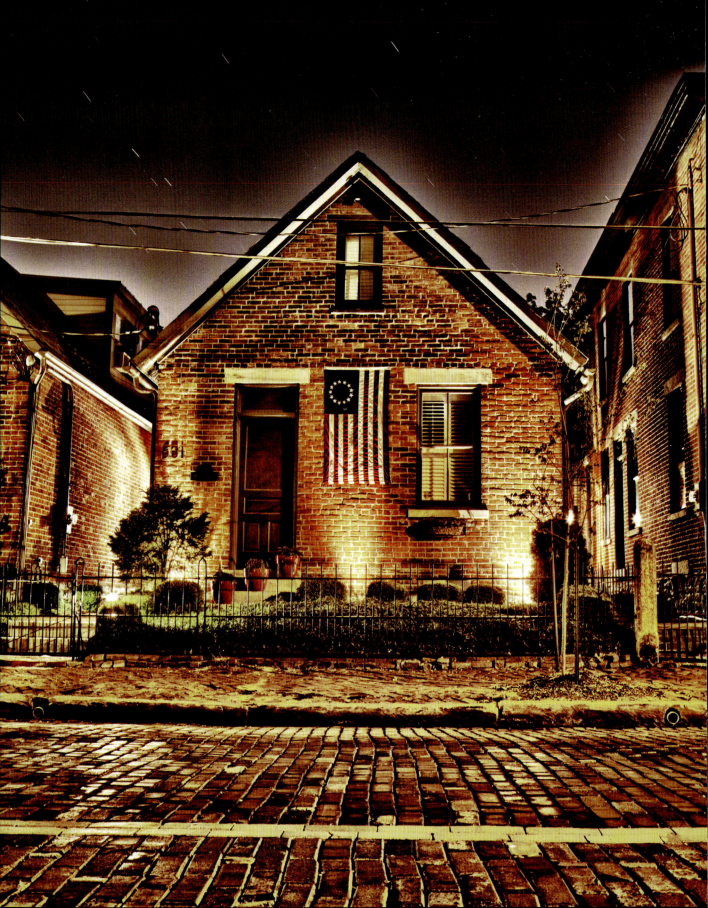

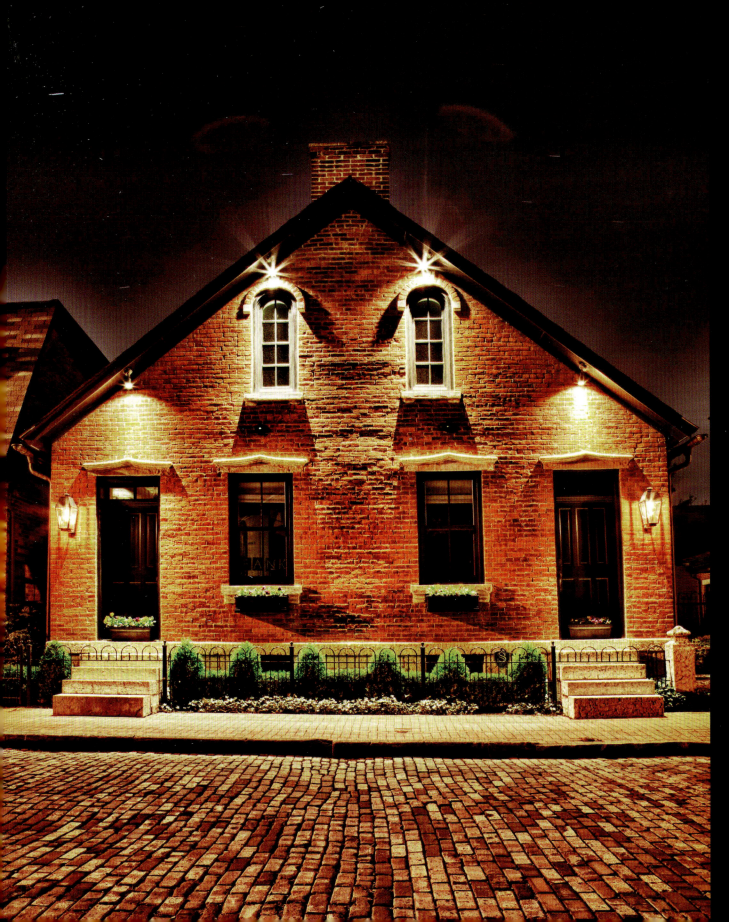

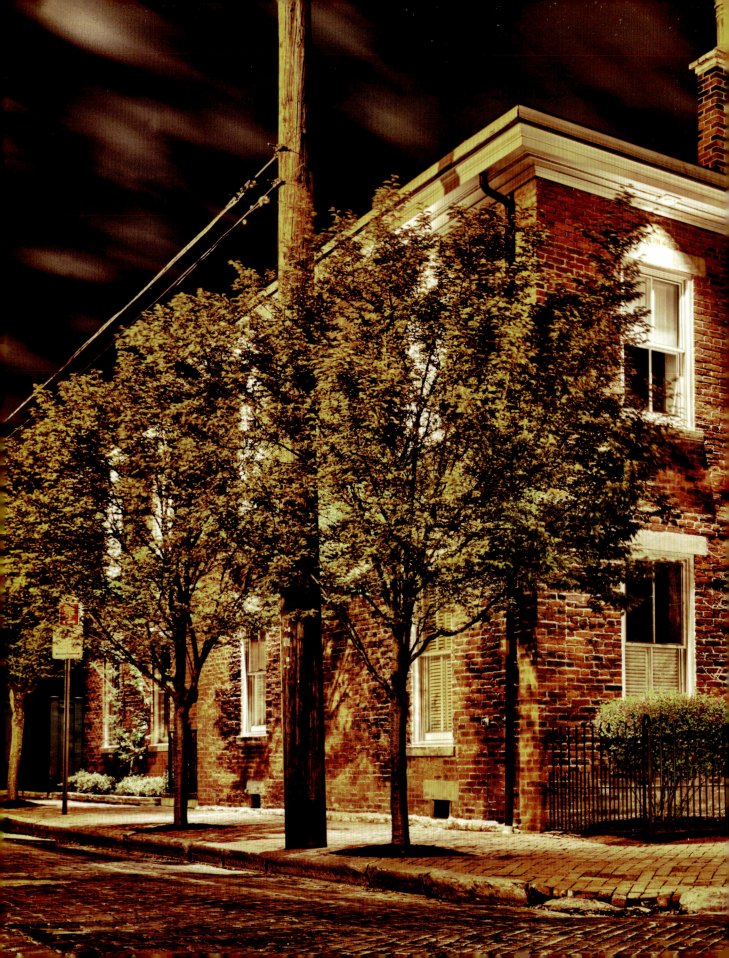

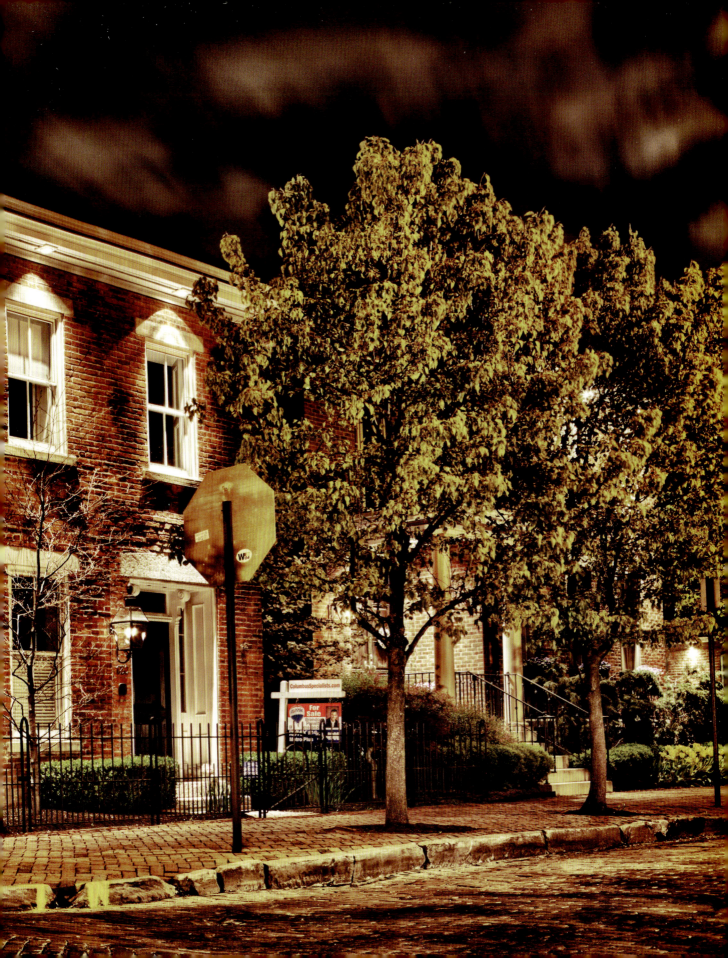

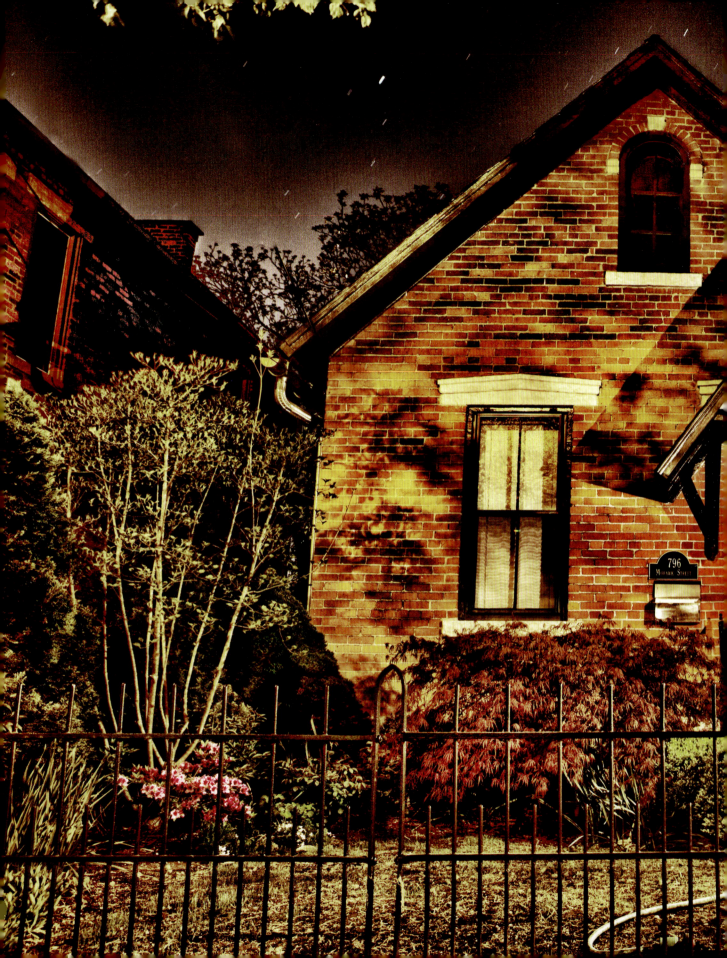

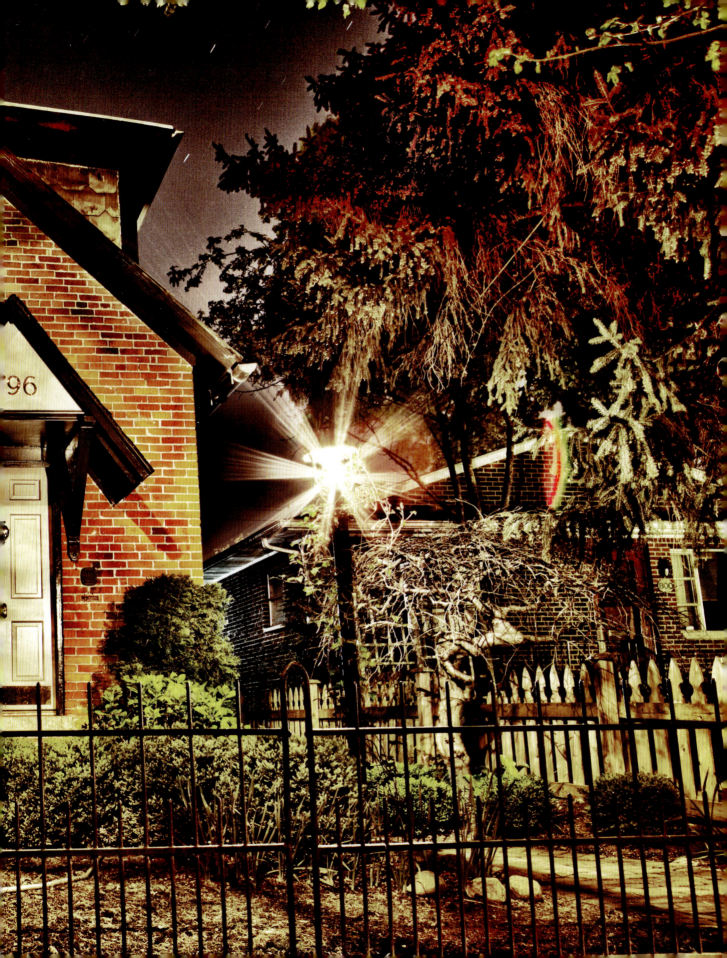

Copyright © 2012 The Brown Boxer LLC

All rights reserved. No part of this book may be reproduced in any form by any electronic or mechanical means without permission in writing from the copyright owner.

ISBN-13: 978-0-615-70941-3
ISBN-10: 0615709419

Book's Website:
www.adimizrahi.com/gvbook.html
www.facebook.com/
NightIntheGermanVillage

Printed in China
The Brown Boxer LLC

To order prints please contact the photographer

adi mizrahi
photographer

www.adimizrahi.com
adi@adimizrahi.com
323.646.0321